A Keepsake

THE JERSEY SHORE

Antelo Devereux Jr.

Schiffer Publishing Ltd

4880 Lower Valley Road • Atglen, PA 19310

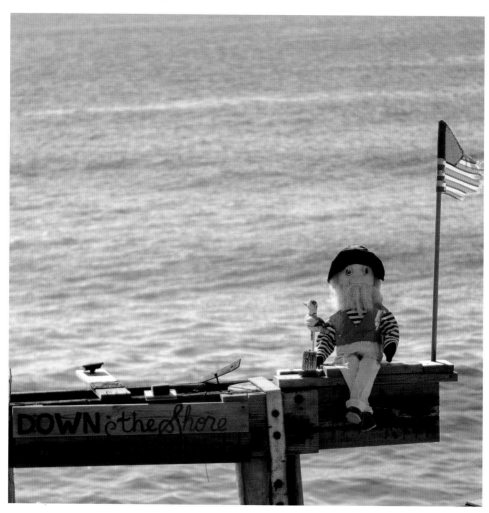

Inhabitants of the Pine Barrens refer to it as "downa shore"—hence down the shore.

INTRODUCTION

The New Jersey Shore is about 130 miles of sand that was once covered by seas as recently as 125,000 years ago. Only in the last 300 years did buildings begin to appear on it as colonists took over the land from the indigenous Lenni-Lenape people. First, most were associated with hunting and fishing, then vacationers began to arrive in ever increasing numbers. Now countless numbers of people live, vacation, and recreate there.

From 30,000 feet, the shore looks to be all the same—a very thin and vulnerable line of sand—and Long Beach Island is the poster child. A closer look reveals an intense, dense variety of buildings and human activity with a few preserved bits of land. Behind it are bays, estuaries, and marshes—essential nurseries for fish and habitats for shore birds. In the grand scheme of things, these wetlands are probably more valuable than the built-up areas on the sand that protects them. Not only do they serve as regenerators of wildlife, but they also absorb flooding and destructive storm surges. One wonders about the vulnerability of that strand of sand, especially if predictions of climate change prove correct. Nevertheless, the shore is an exciting and fun place to visit and a major driver of New Jersey's economy.

Over the years I have partaken of just about all of the offerings of the Jersey Shore: sunbathing, swimming, hotels, casinos, boardwalk arcades and amusement piers, and even duck hunting. I enjoy exploring by car or by foot on boardwalks, the smell of the sea air, and the calming sound of waves in the background. The eighty-five images herein capture some of the sights and scenes that to my eye characterize the shore from Atlantic Highlands and Sandy Hook to Cape May. I hope the viewer enjoys them as much as I did shooting them.

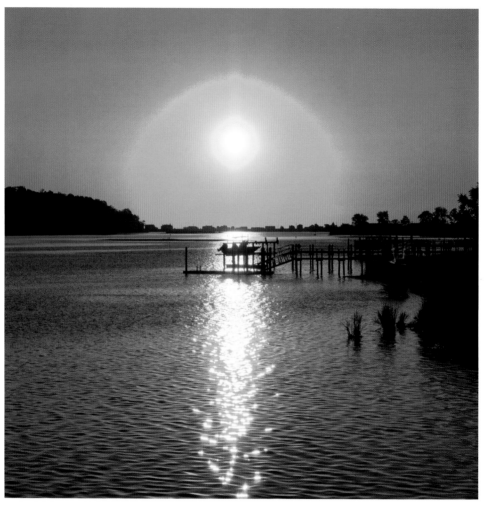

Rumson, Navesink River

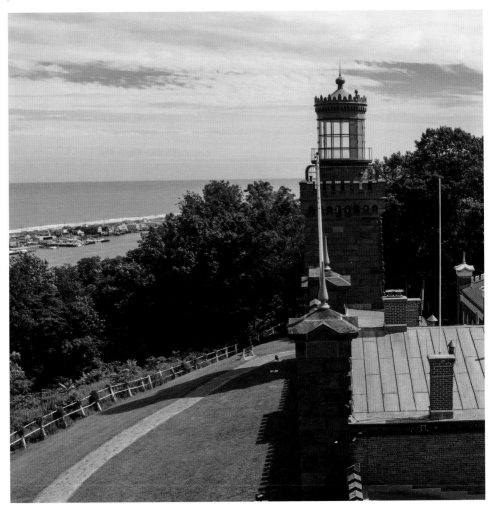

Atlantic Highlands

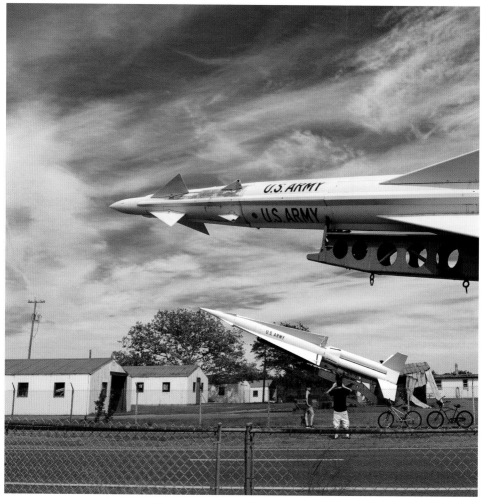

Sandy Hook, Fort Mason

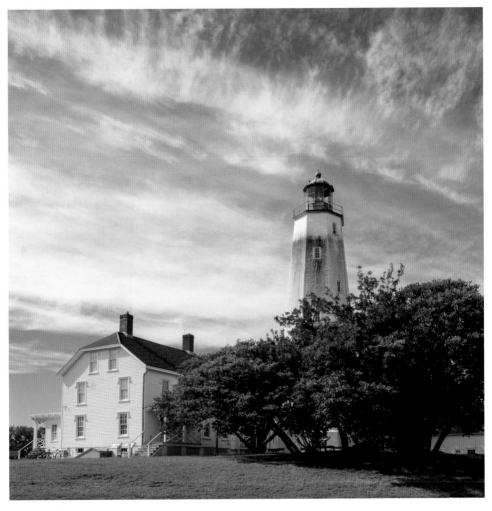

Sandy Hook

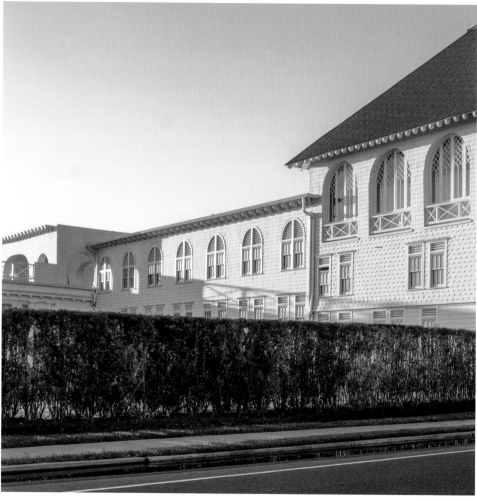

Monmouth

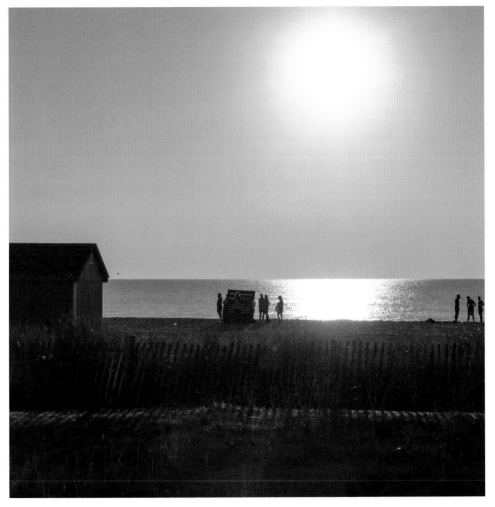

Monmouth

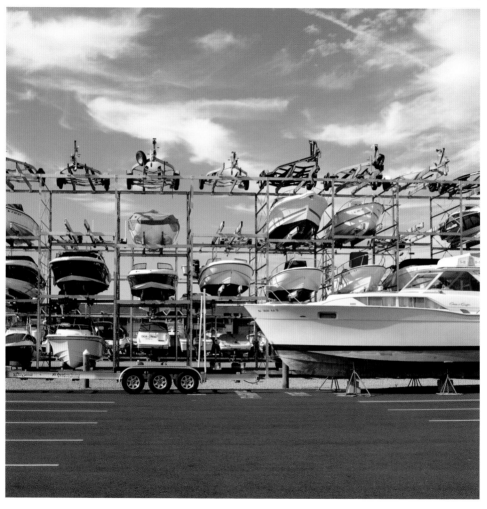

Sea Bright

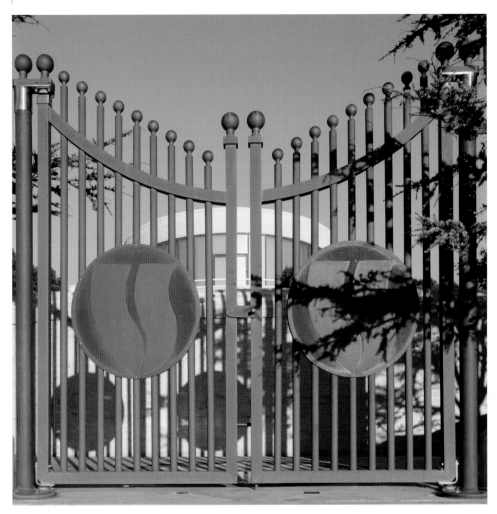

Elberon

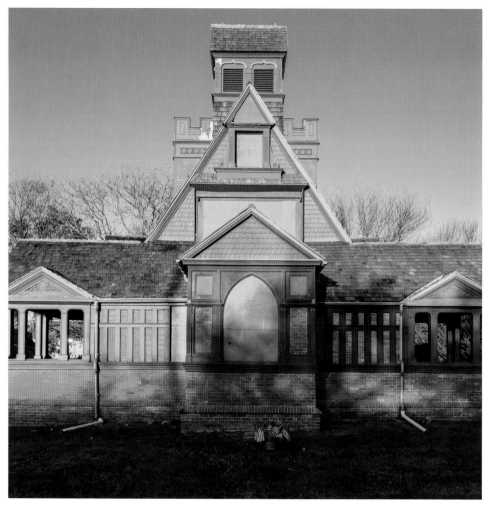

Church of the Presidents, Elberon

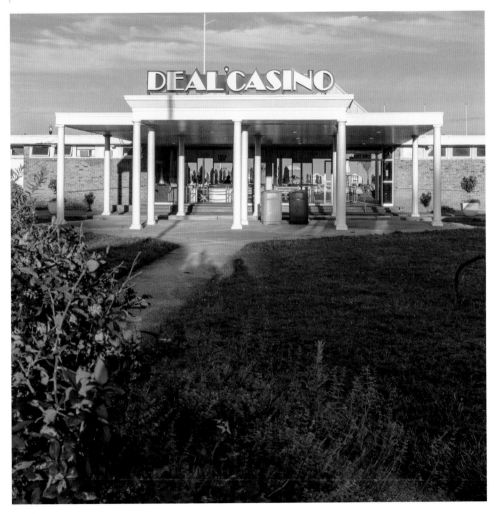

Deal

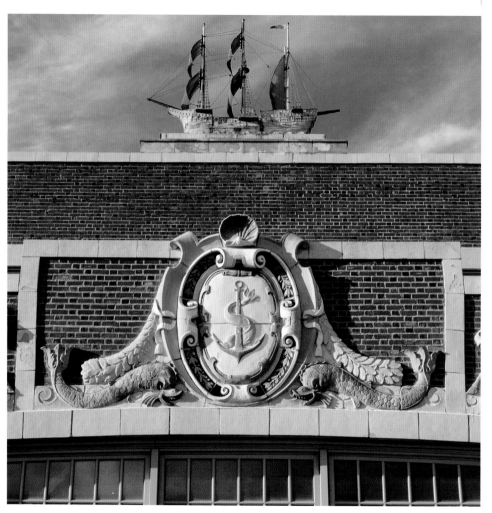

Asbury Park

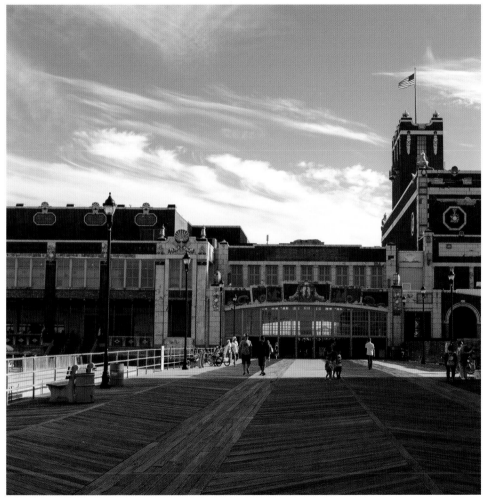

Asbury Park

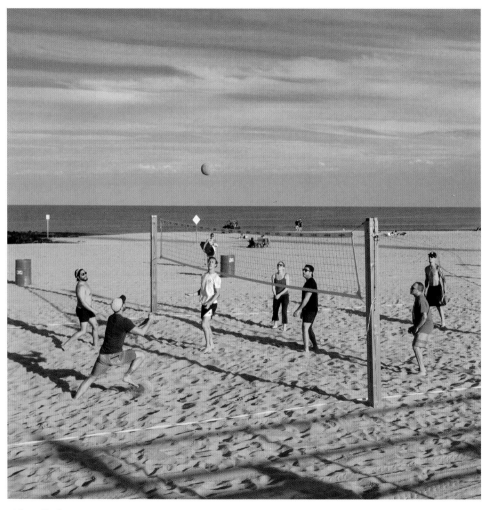

Asbury Park

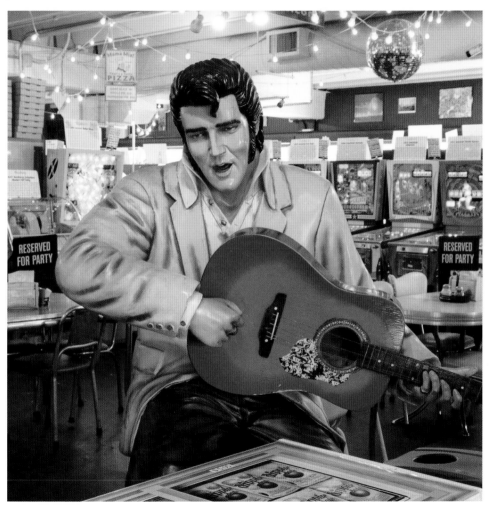

Asbury Park

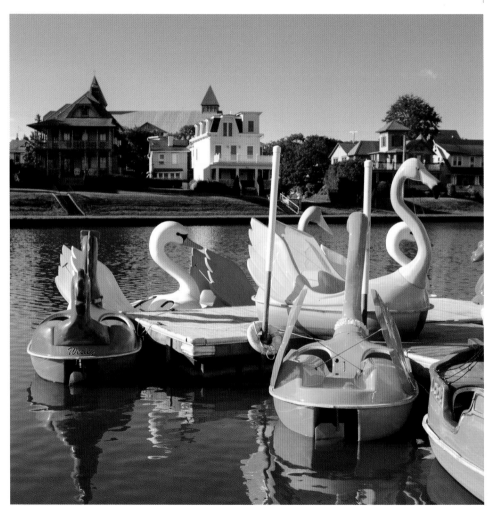

Asbury Park

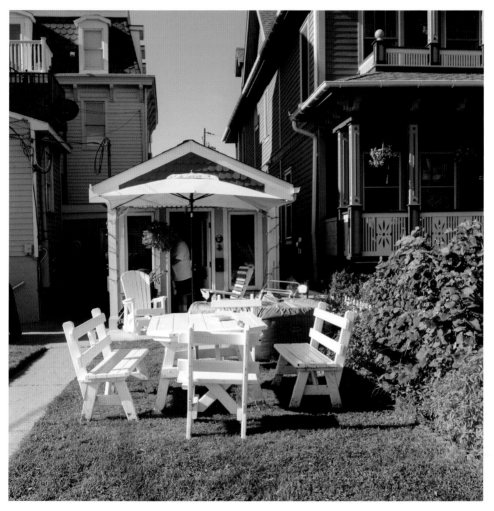

Ocean Grove

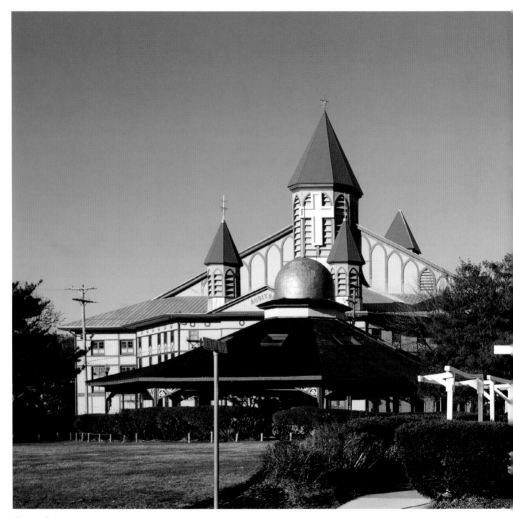

Ocean Grove

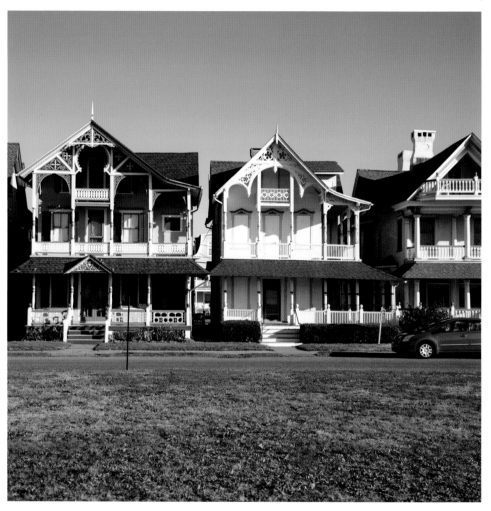

Ocean Grove

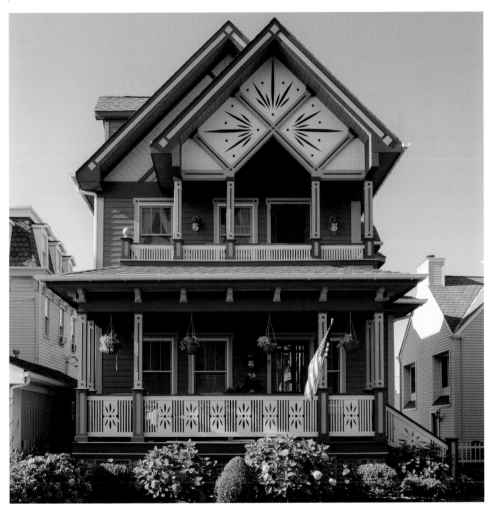

Ocean Grove

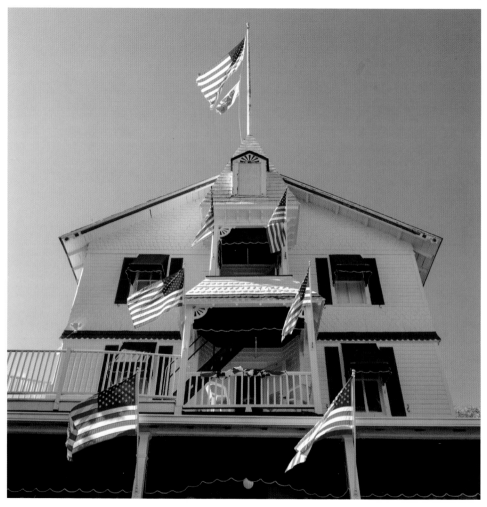

Sea Girt

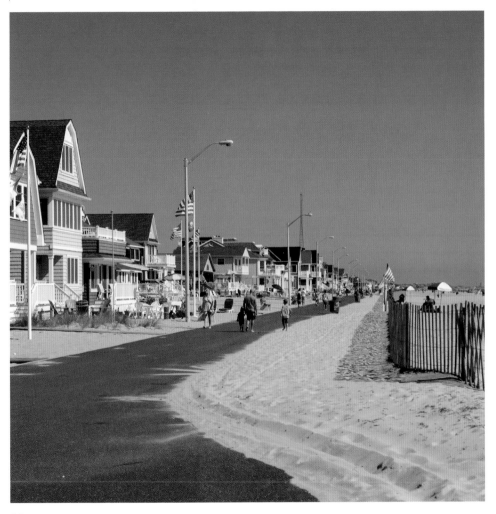

Manasquan

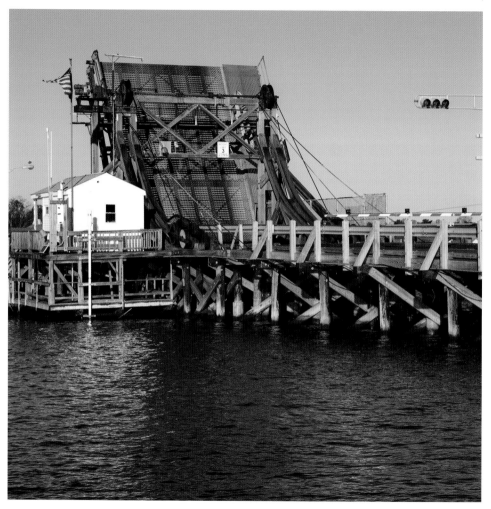

Glimmer Glass Bridge, Manasquan

Bayhead

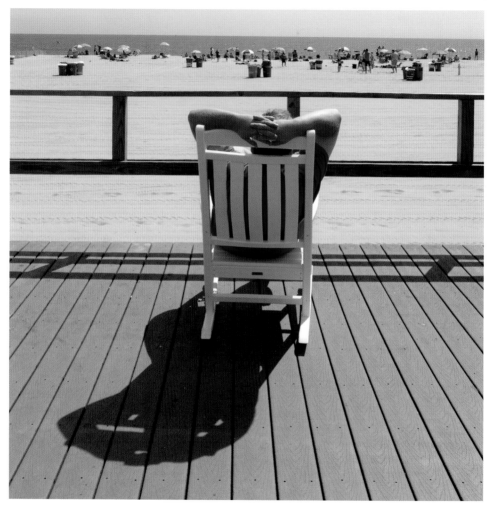

Point Pleasant

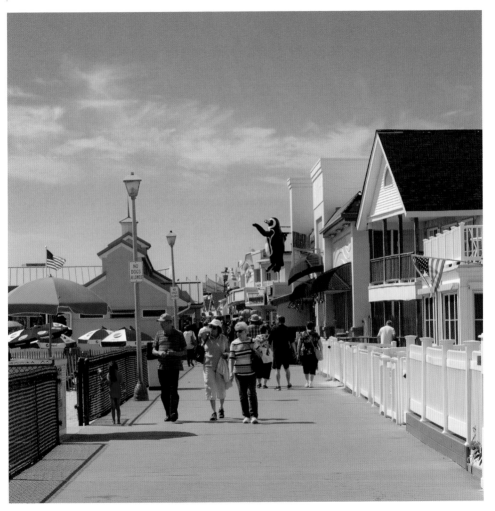

Point Pleasant

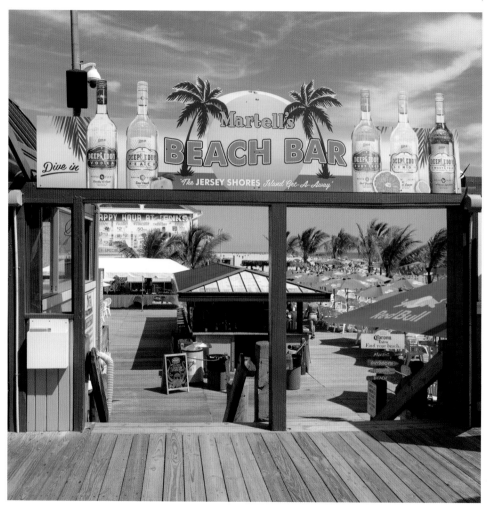

Point Pleasant

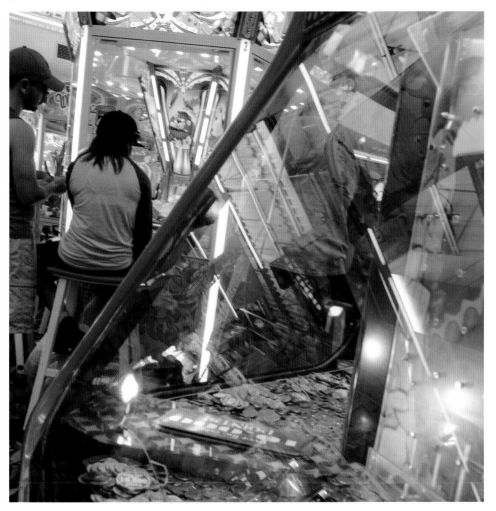

Point Pleasant

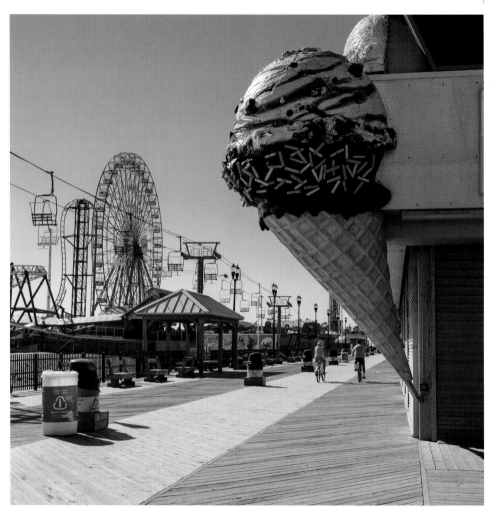

Point Pleasant

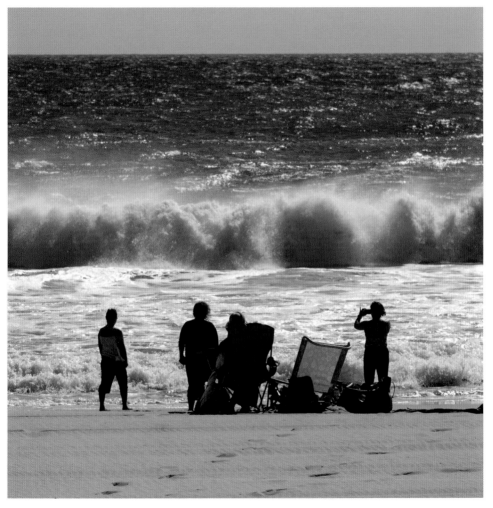

Point Pleasant

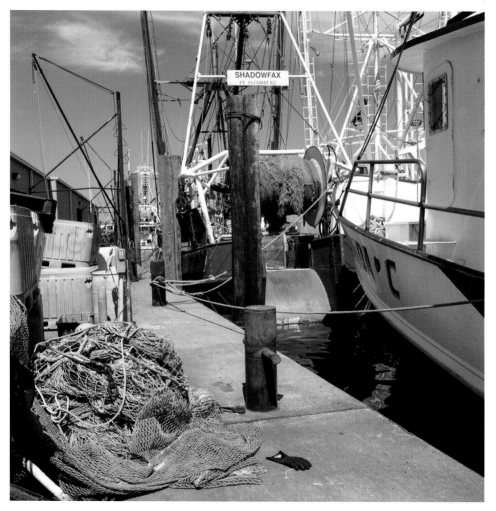

Long Beach Island

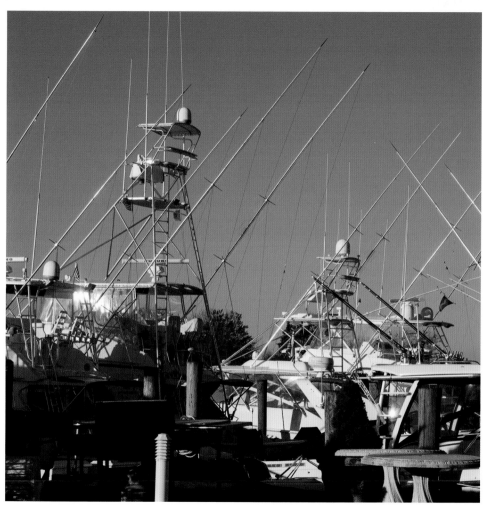

Manasquan

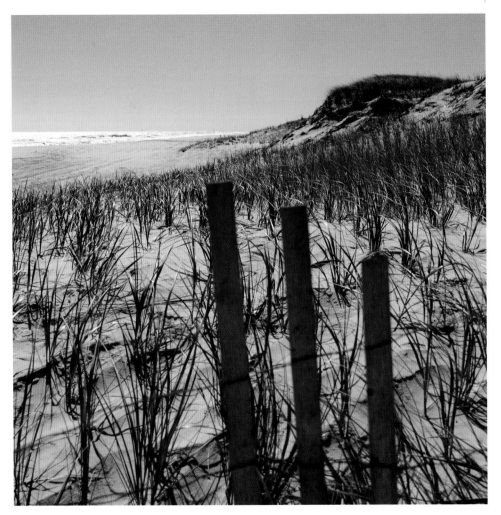

Island Beach State Park, Long Beach Island

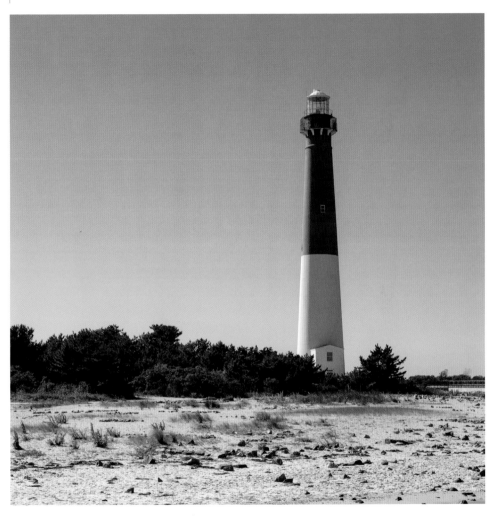

Barnegat Lighthouse, Long Beach Island

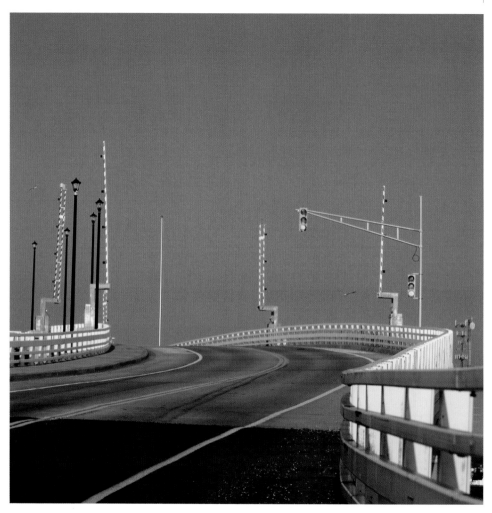

Long Beach Island

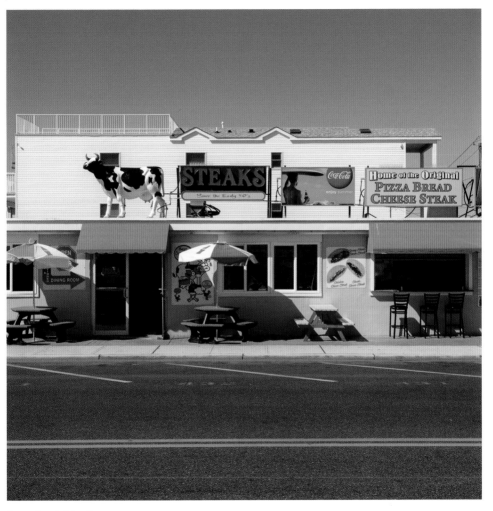

Long Beach Island

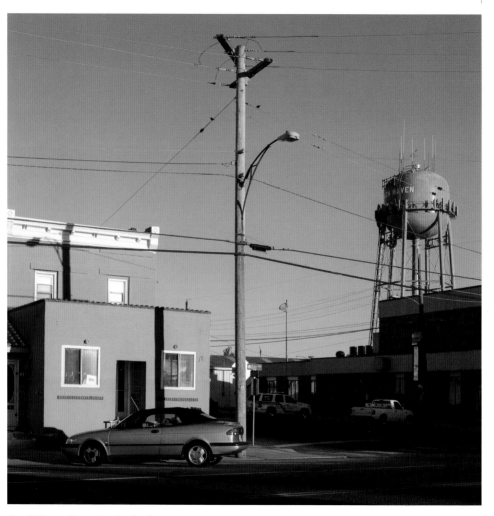

Beach Haven, Long Beach Island

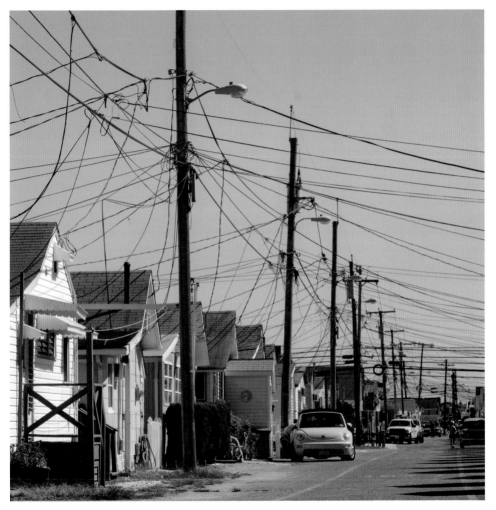

Beach Haven, Long Beach Island

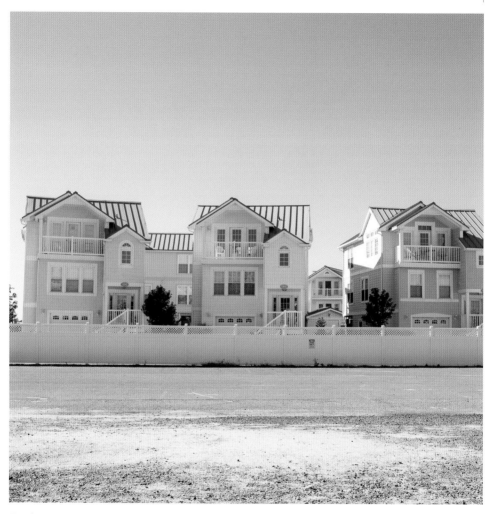

Beach Haven, Long Beach Island

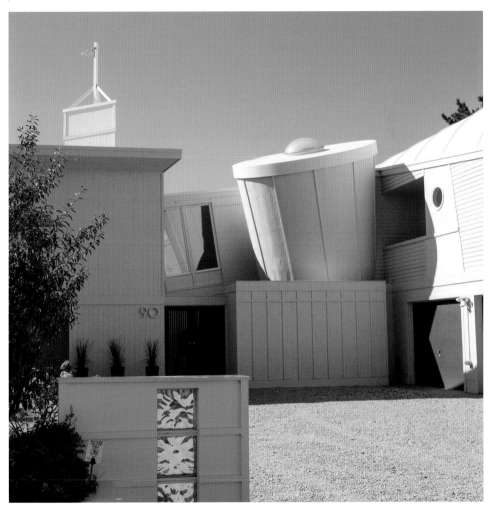

Harvey Cedars, Long Beach Island

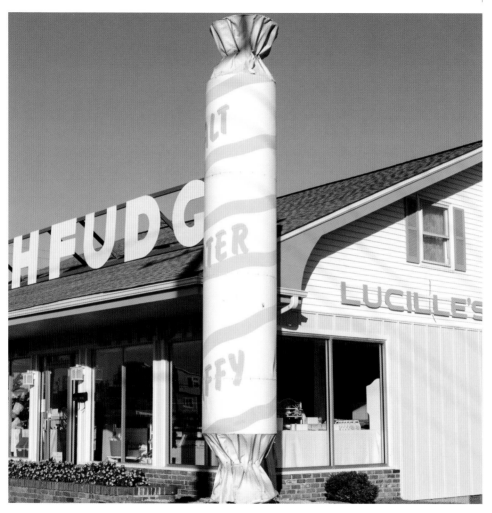

Beach Haven, Long Beach Island

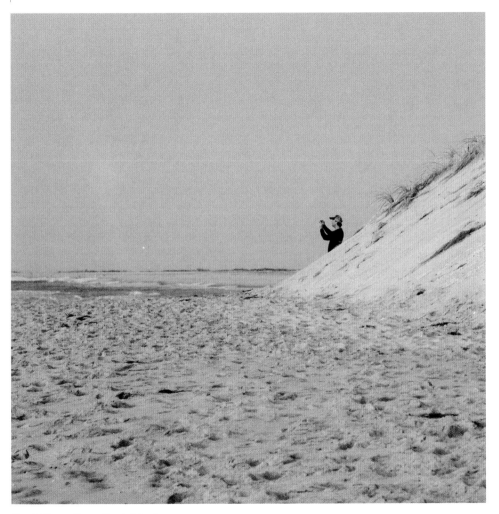

Beach Haven, Long Beach Island

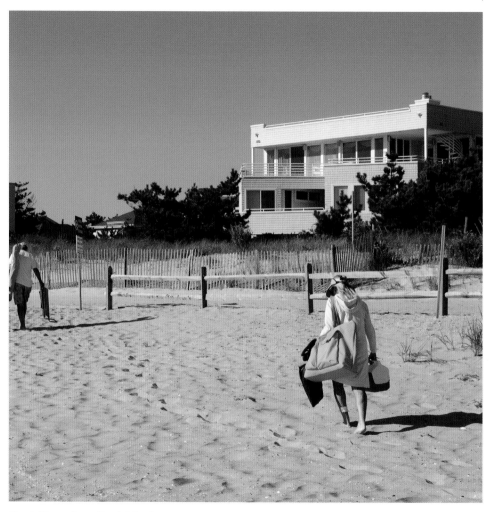

Beach Haven, Long Beach Island

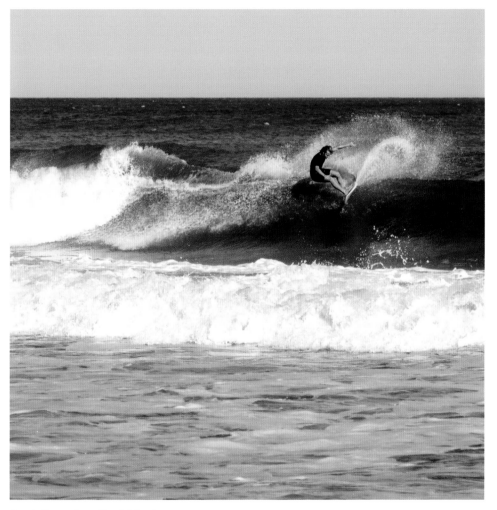

Beach Haven, Long Beach Island

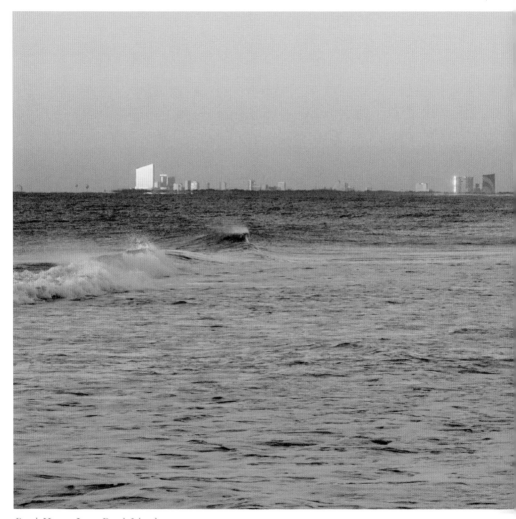

Beach Haven, Long Beach Island

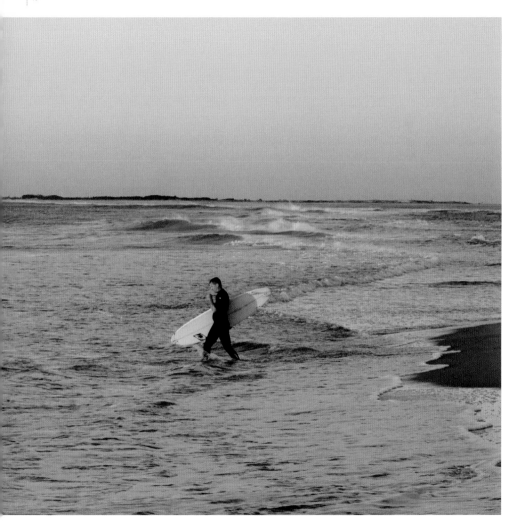

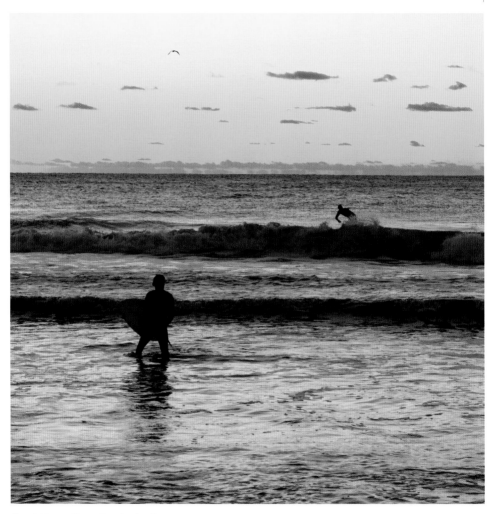

Beach Haven, Long Beach Island

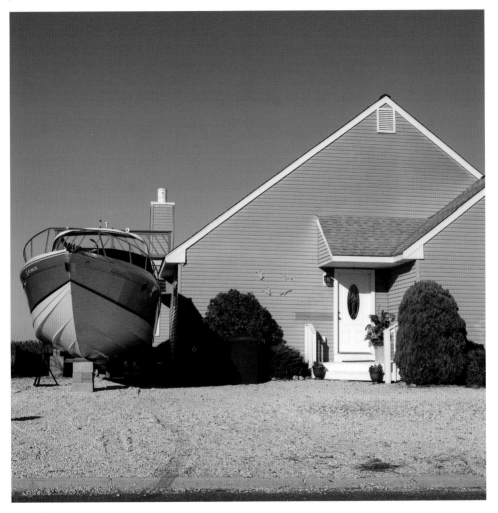

Beach Haven West

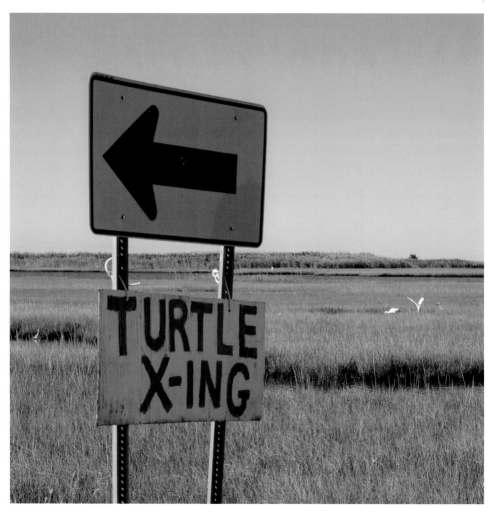

Tuckerton area

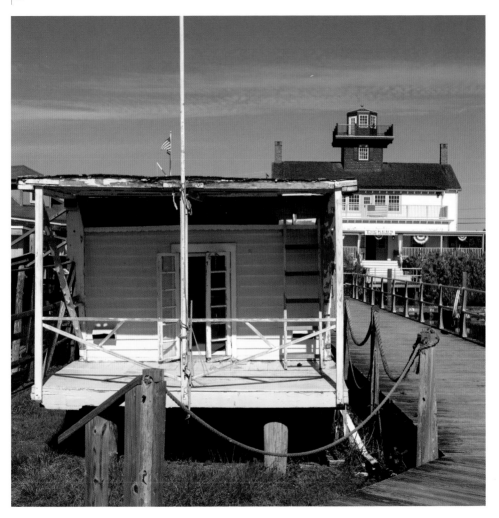

Tuckerton Seaport

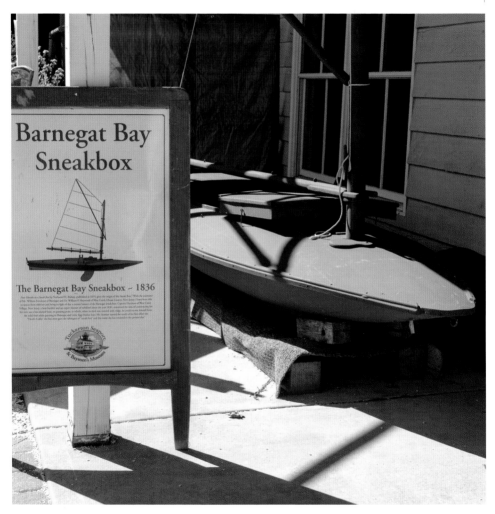

Tuckerton Seaport

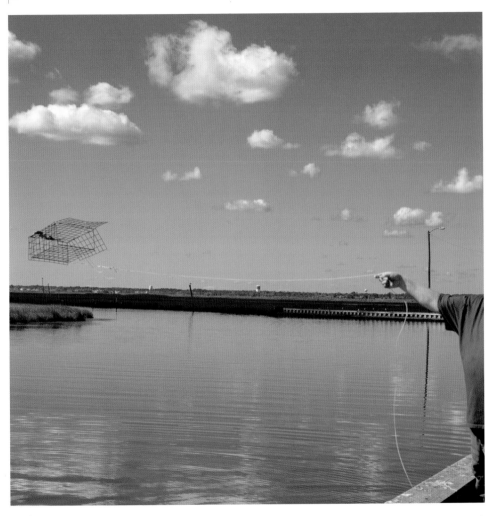

Parkertown

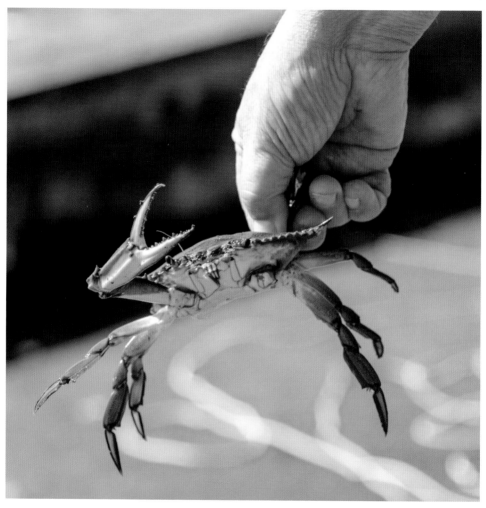

Parkertown

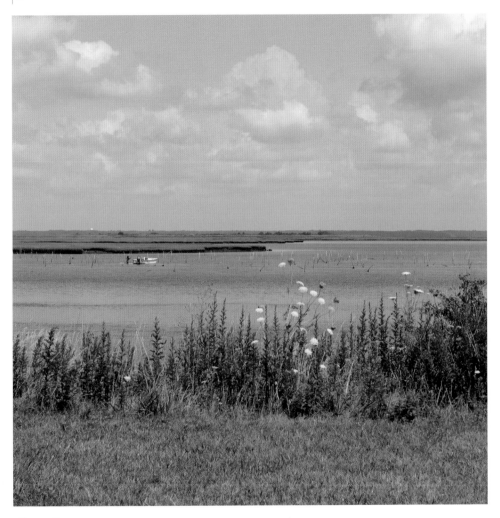

Absecon Bay

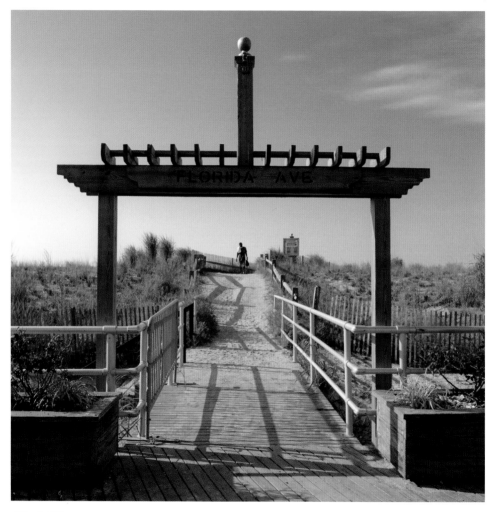

Atlantic City

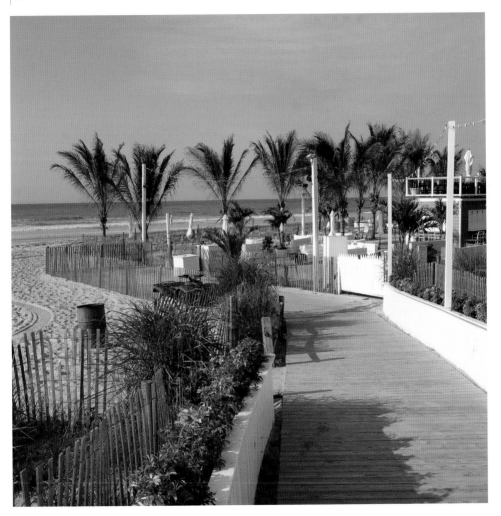

Atlantic City

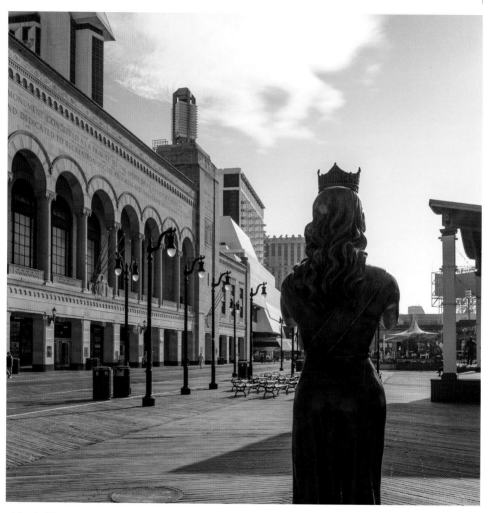

Atlantic City

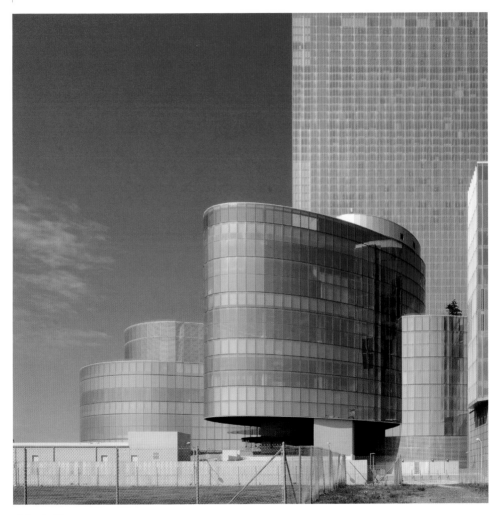

Atlantic City

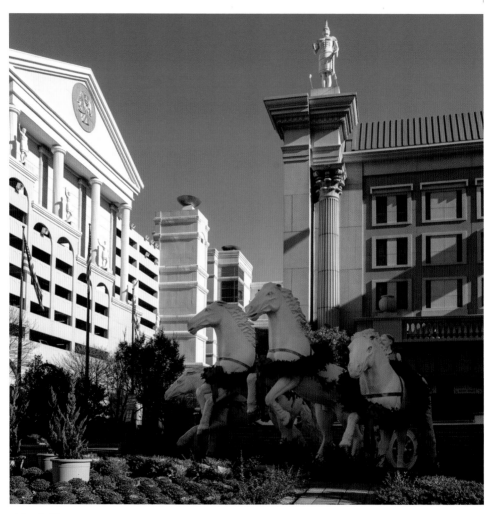

Atlantic City

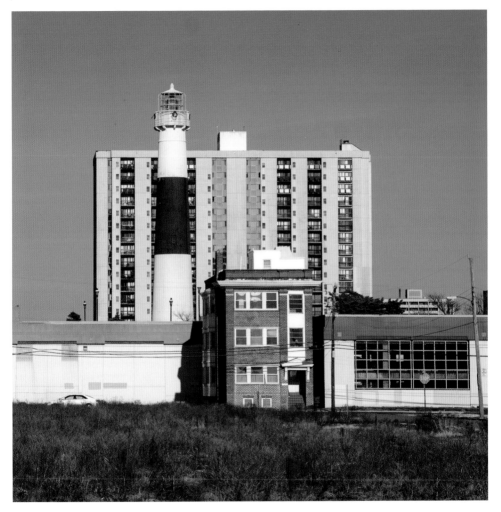

Absecon Lighthouse, Atlantic City

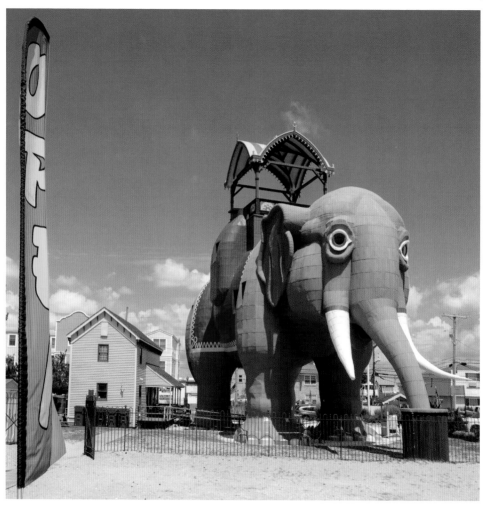

Lucy, Margate

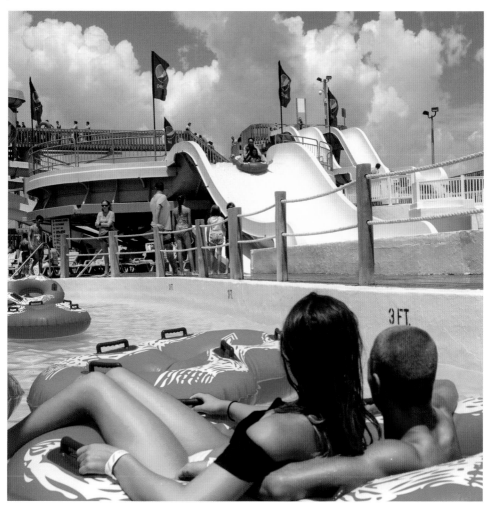

Ocean City

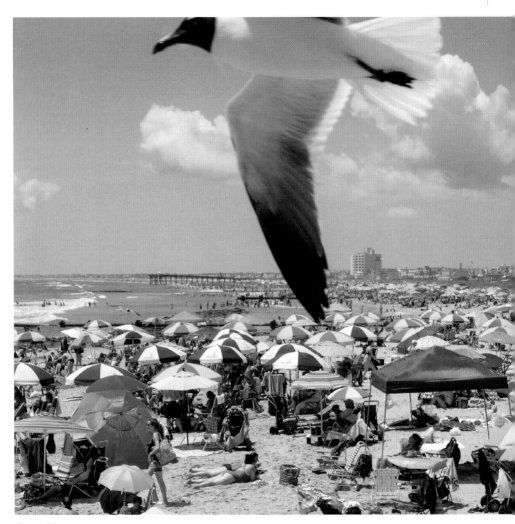

Ocean City

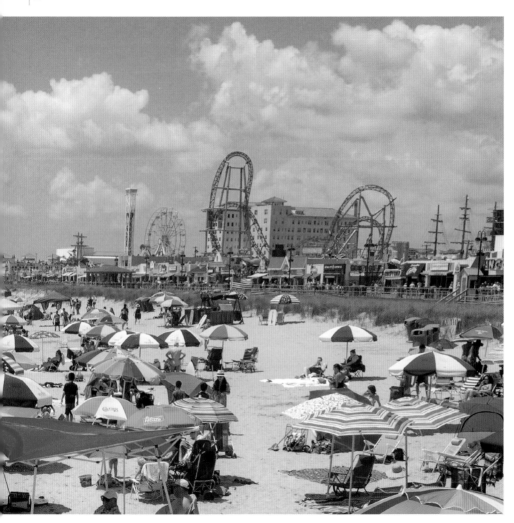

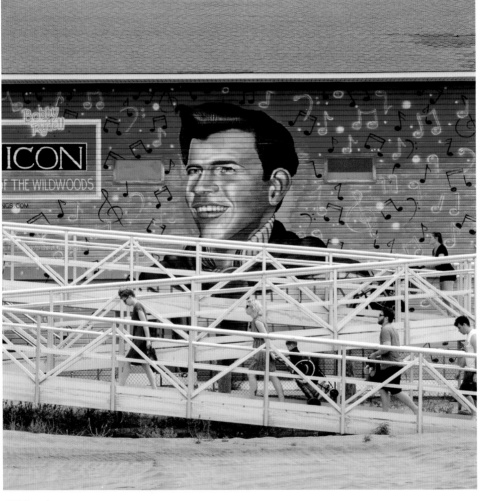

Wildwood

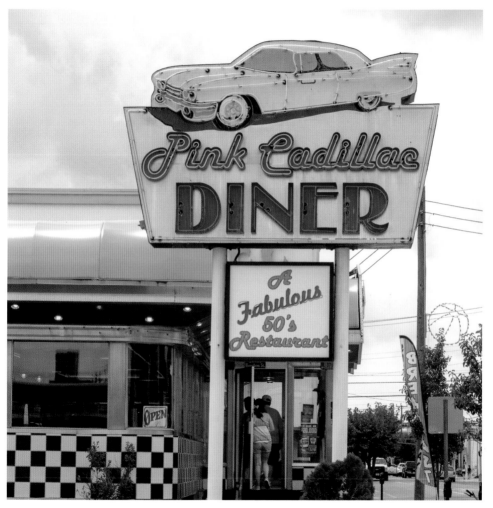

Wildwood

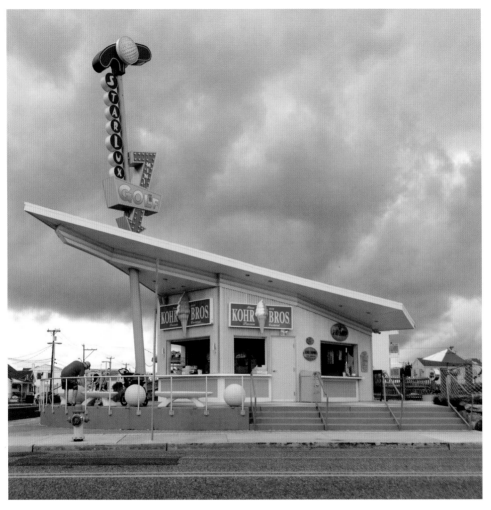

Wildwood

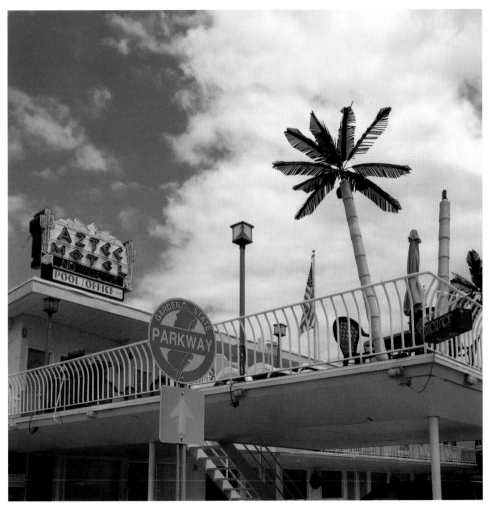

Wildwood

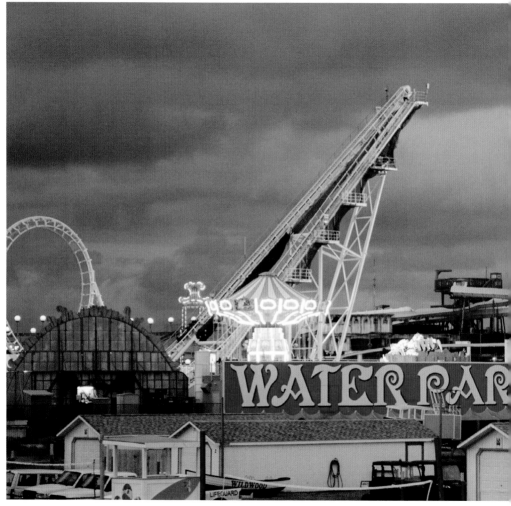

Wildwood

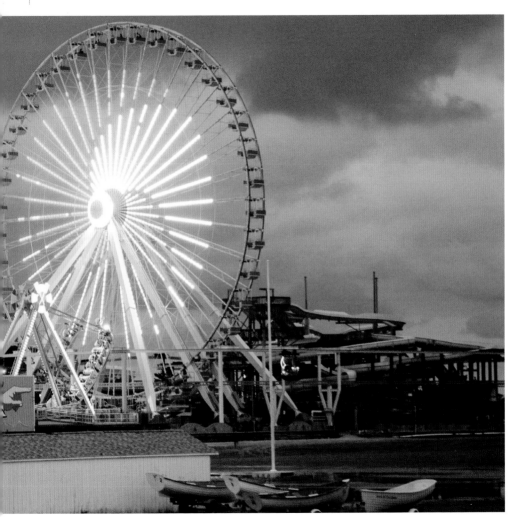

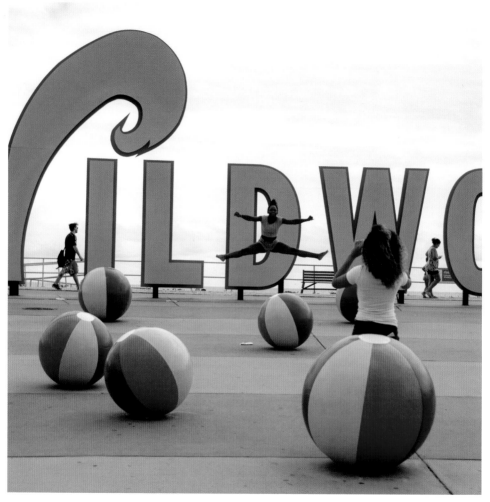

Wildwood

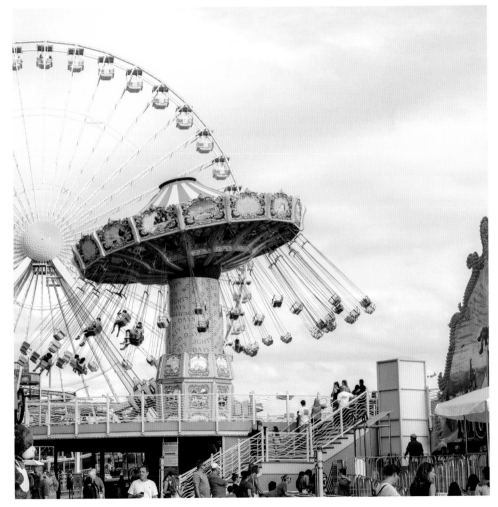

Wildwood

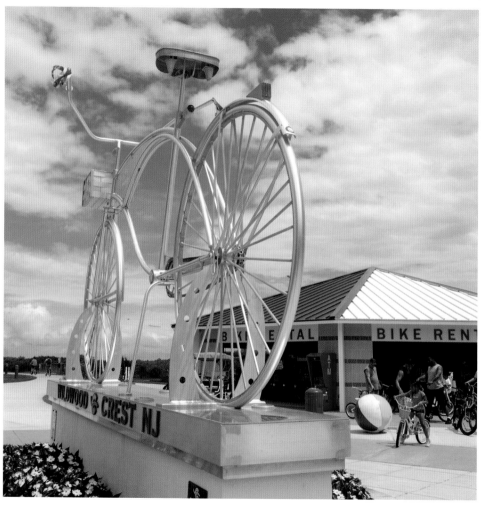

Wildwood

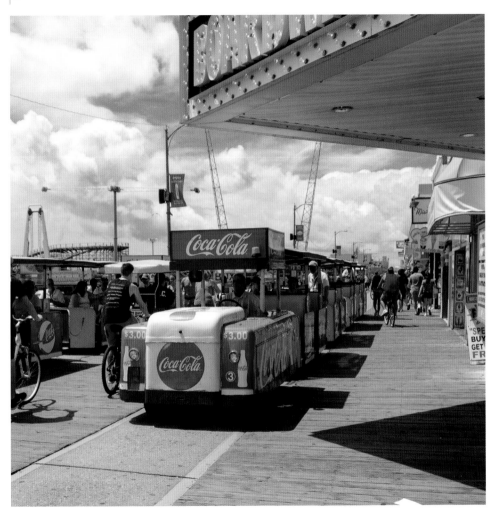

Wildwood

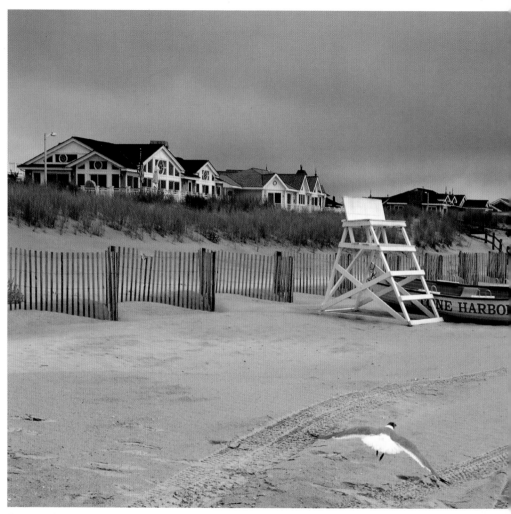

Stone Harbor

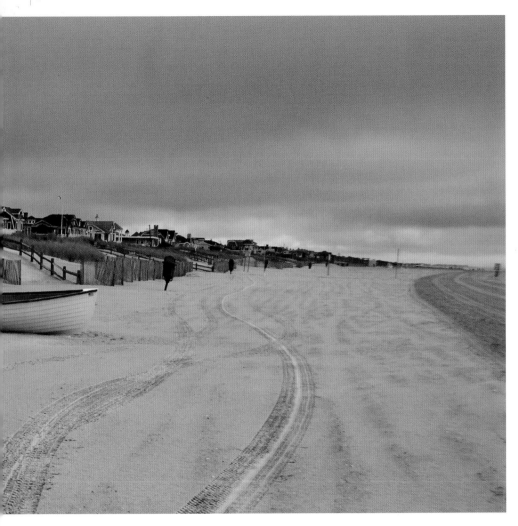

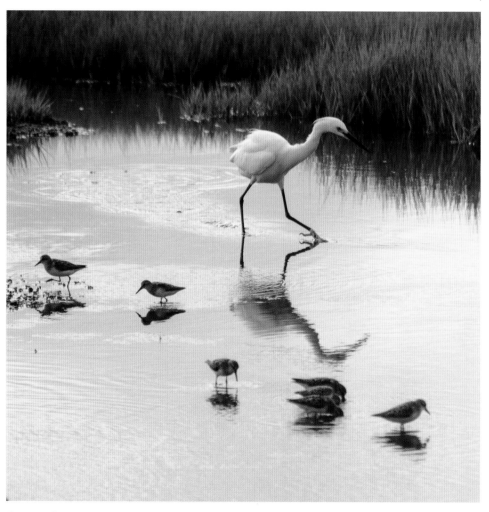

Stone Harbor

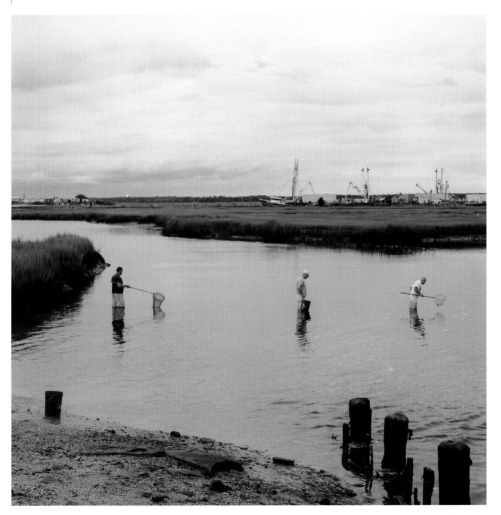

Wildwood

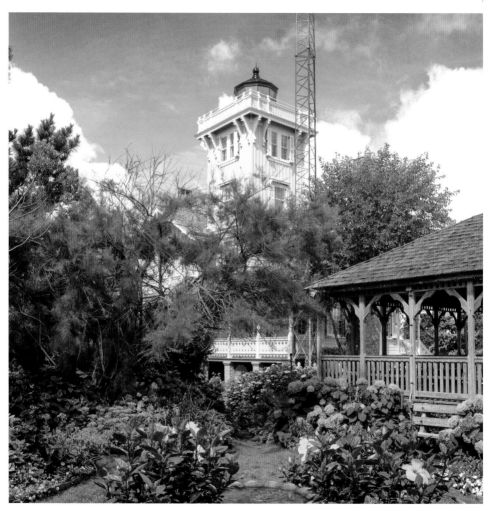

Hereford Inlet Lighthouse, North Wildwood

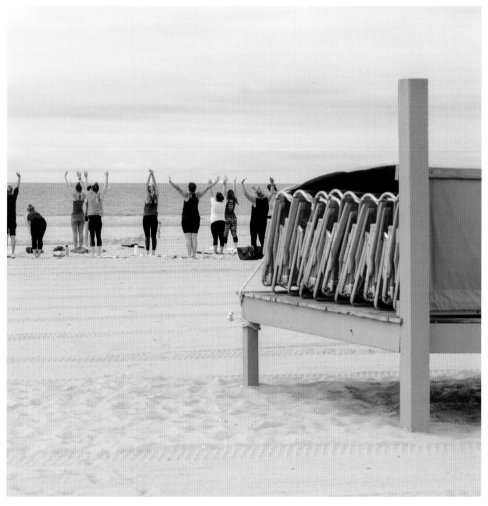

Cape May

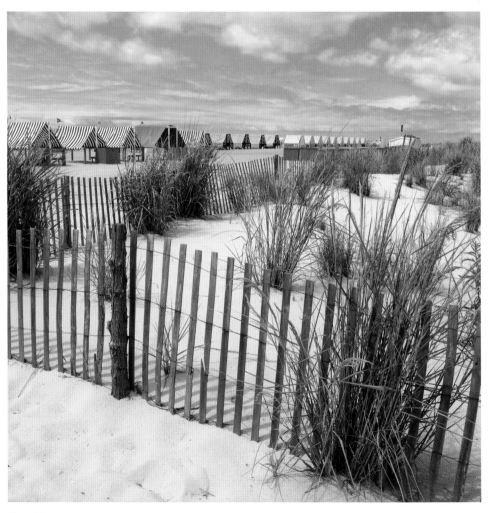

Cape May

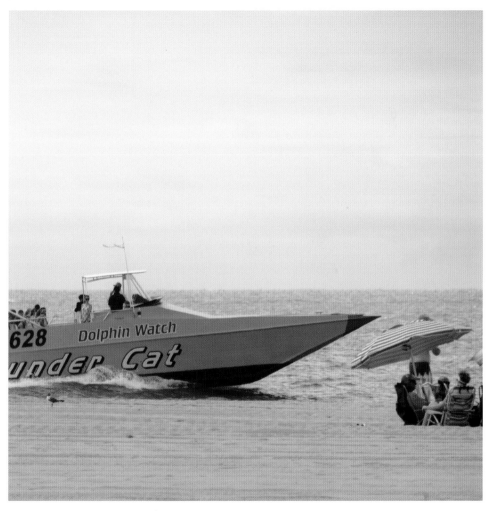

Cape May

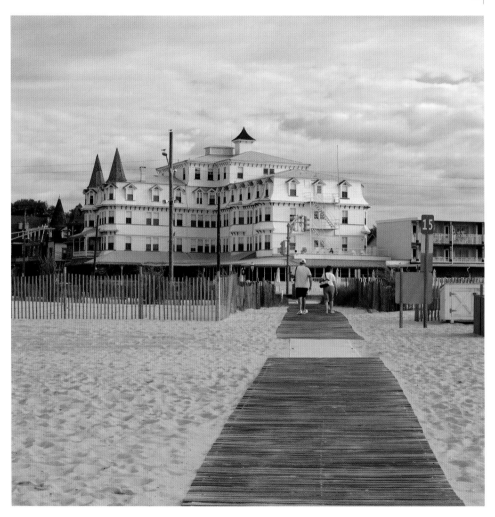

Cape May

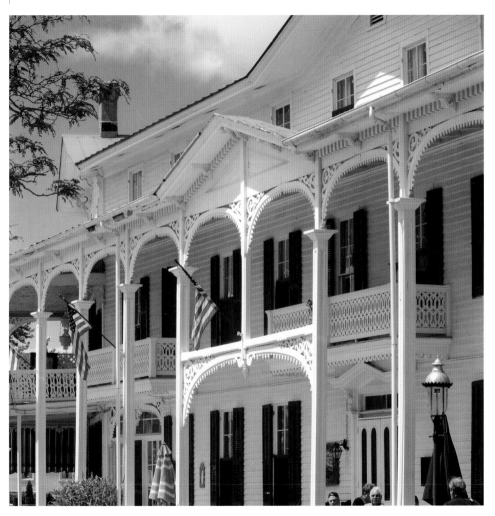

Cape May

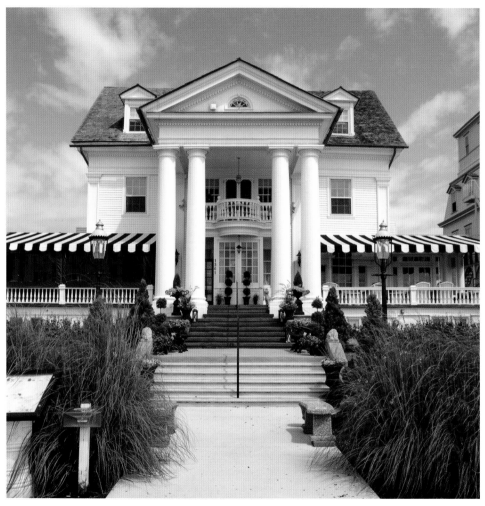

Cape May

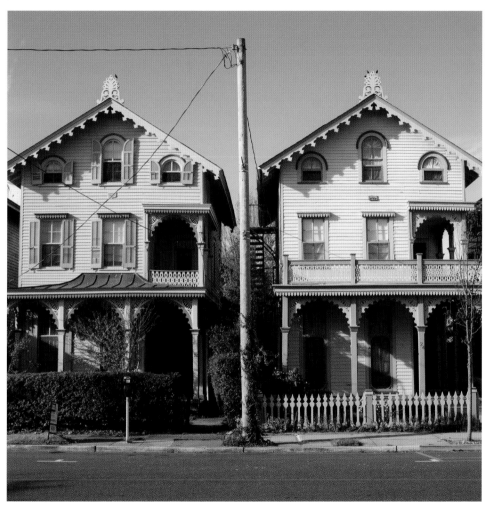

Cape May

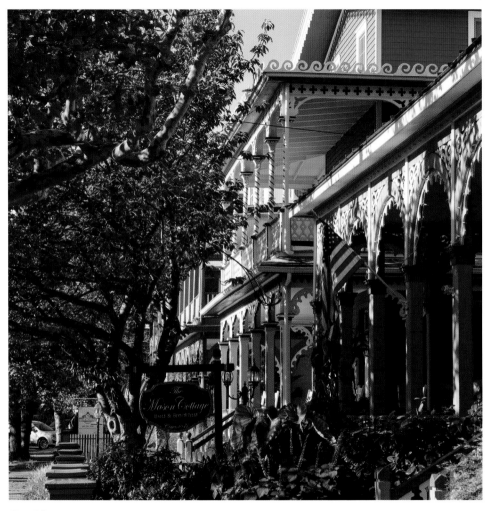

Cape May

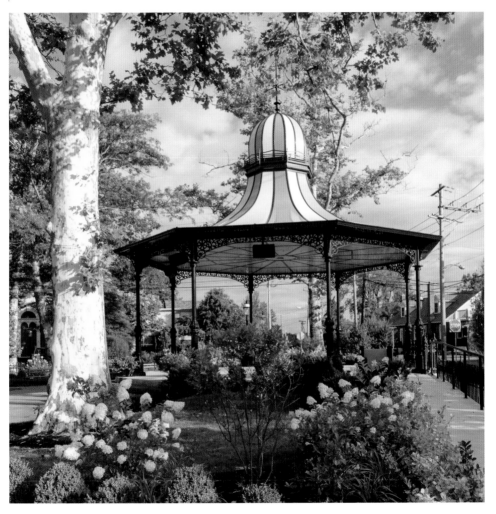

Cape May

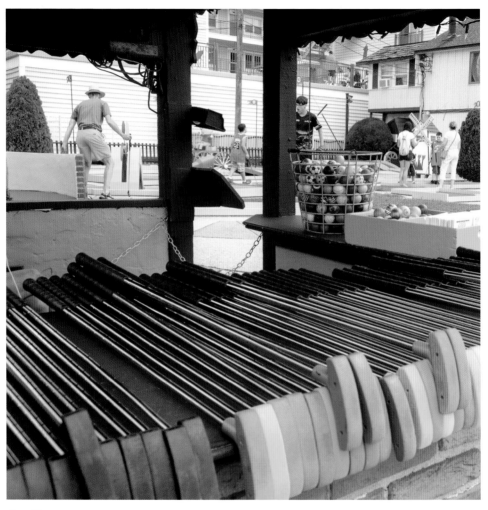

Cape May

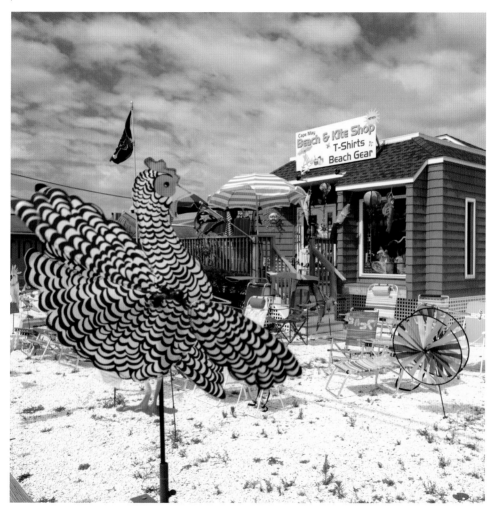

Cape May

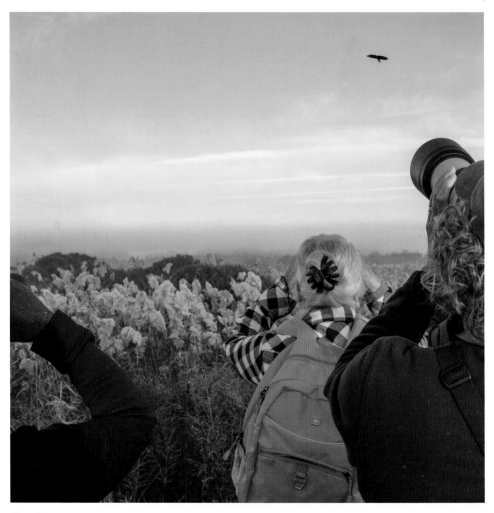

Cape May

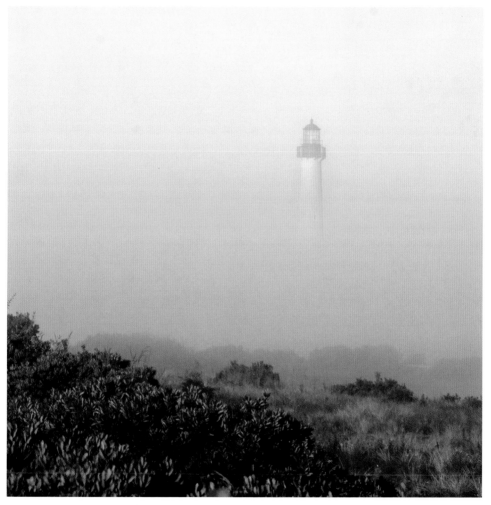

Cape May Lighthouse

Antelo Devereux Jr. has been photographing for the better part of his life, first as an amateur and more recently as a professional. He has published seven books and has exhibited his images in various venues and galleries in Maine, Vermont, Pennsylvania, and Delaware. He has degrees from Harvard University and the University of Pennsylvania and has studied at Maine Media Workshops. He lives with his family in Pennsylvania and summers in Maine. His photographs can be seen on Instagram.
@photoeye1

ISBN: 978-0-7643-5576-9
Printed in China

Published by Schiffer Publishing, Ltd.
4880 Lower Valley Road
Atglen, PA 19310
Phone: (610) 593-1777; Fax: (610) 593-2002
E-mail: Info@schifferbooks.com
Web: www.schifferbooks.com

For our complete selection of fine books on this and related subjects, please visit our website at www.schifferbooks.com. You may also write for a free catalog.

Schiffer Publishing's titles are available at special discounts for bulk purchases for sales promotions or premiums. Special editions, including personalized covers, corporate imprints, and excerpts, can be created in large quantities for special needs. For more information, contact the publisher.

We are always looking for people to write books on new and related subjects. If you have an idea for a book, please contact us at proposals@schifferbooks.com.